IMAGES
of America

LA PLATA COUNTY

Moffat
Routt
Jackson
Larimer
Logan
Sedgw
Phillip

Rio Blanco
Grand
Boulder
Weld
Morgan
Adams
Washington
Yuma

Garfield
Eagle
1
Clear
Creek
3
Arapahoe
Jefferson
2

Mesa
Pitkin
Lake
Park
Douglas
Elbert
Kit
Carson

Delta
Gunnison
Chaffee
Teller
El Paso
Lincoln
Cheyenne

Montrose
Fremont
Crowley
Kiowa

Ouray
Saguache
Custer
Pueblo

San Miguel
Hinsdale
Mineral
Otero
Bent
Prowe

Dolores
San
Juan
Rio
Grande
Alamosa
Huerfano
Las Animas
Baca

Montezuma
La
Plata
Archuleta
Conejos
Costilla

riginal La Plata County Outlined

Present-day Colorado Counties

Established in 1874 from parts of Lake and Conejos Counties, La Plata County underwent two distinct boundary modifications in 1876 and 1889. The county lost area with the creation of San Juan County in 1876 and Montezuma County in 1889. Originally 6,485 square miles in size, today the county is 1,700 square miles. The white outline shows approximate original boundaries. (Map by Lee Zion; courtesy Colorado GenWeb.)

ON THE COVER: Dr. Benjamin Ochsner took this "Rite of Spring" photograph at Electra Lake in 1935. The La Plata County physician was known for his unusual but captivating photographs. His obituary read, "Considered one of the world's most consistent contributors to national and international photography salons, the doctor became one of the few Americans honored with a fellowship in the Royal Photography Society of London." (Courtesy La Plata County Historical Society.)

IMAGES
of America

LA PLATA COUNTY

Edward Anthony Horvat

ARCADIA
PUBLISHING

Published by Arcadia Publishing
Charleston, South Carolina

Printed in the United States of America

Library of Congress Control Number: 2023948143

For all general information, please contact Arcadia Publishing:
Telephone 843-853-2070
Fax 843-853-0044
E-mail sales@arcadiapublishing.com

Visit us on the Internet at www.arcadiapublishing.com

*To my wife, Sue, who continuously replenishes my physical,
emotional, intellectual, and spiritual energies*

CONTENTS

ACKNOWLEDGMENTS

The history of La Plata County, Colorado, is one of extremes. The first Indigenous peoples had severe environmental challenges that made day-to-day survival uncertain. Later, Euro-American settlers were also not immune to the harsh environment and its occasional indiscriminate acts of misfortune. Not all misfortunes were caused by nature, however. Human and societal conflicts could be overwhelming for residents physically and economically as well as emotionally.

Many historians and storytellers have documented these challenges and successes of life in the county. This book of images attempts to add a minor chapter to that record. A fair number of citizens made great efforts to capture on film the people, landscapes, and events that make this part of Colorado unique. It also took determined friends and family to ensure the images were preserved through donations to the La Plata County Historical Society. It is with singular gratitude that we thank these people for their safeguarding of history.

The La Plata County Historical Society works every day to preserve local history, and since its founding in 1972, hundreds of volunteers have furthered the work of preserving local history. A special thank-you to them is fitting.

Many books, articles, and documents within the museum's library used for fact-checking were invaluable. Authors Richard K. Young, Robert Delaney, Duane Smith, Alan Nossaman, Jill Seyfarth, and Ruth Lambert all deserve special recognition.

Three people associated with the Animas Museum were of particular help in the preparation of this manuscript. Susan Jones, board member and collections specialist, has given many hours of research, help, and advice. Charles DiFerdinando, a museum staff member and noted local historian, has spent extensive time reviewing, editing, and improving the historical context within. Lastly, Larry Bollinger, the museum's digital expert, has assisted greatly in obtaining, scanning, and ensuring the photographs are of the best quality. To these three, I give my greatest and sincerest appreciation.

All images appear courtesy of the La Plata County Historical Society Museum.

INTRODUCTION

When Will Rogers, one of America's most famous humorists and entertainers, visited La Plata County in July 1935, he made an interesting observation of the region in his nationally syndicated column. Referring to the area he wrote, "Out of the way, and glad of it." He was not wrong. The county in southwest Colorado is not on what one might call "the beaten path." In many respects, the county remains somewhat isolated today. Rarely do travelers happen to cross the county on their way to another destination, as it is not located along a major thoroughfare crossing the nation. Travelers come to the county in scores but typically as a destination of its own, not as a waypoint on the way to somewhere else. The nearest metropolitan city is Albuquerque, one state and 215 miles away. The nearest interstate highway is almost a three-hour drive away.

Discovered by Hollywood in the 1940s and 1950s, many classic motion pictures filmed their location shoots in La Plata County. Hollywood legends Marilyn Monroe, Clark Gable, Jimmy Stewart, Barbara Stanwyck, Janet Leigh, John Wayne, Paul Newman, and Robert Redford all came to film motion pictures. The major studios wanted the impressive scenery and often the Denver & Rio Grande Western Railroad (D&RGW) that traverses the county to provide beauty and realism to their films. Westerns of course predominated. These Hollywood movies introduced the whole nation to the splendor of the area, and a fledgling tourist industry grew to sustain the local economy.

The impetus in Colorado to organize and create specific county boundaries was primarily related to the presence of natural resources, specifically the discovery of great mineral wealth within its regions. The Brunot Agreement, ratified in 1874, was negotiated between the US government and the Ute tribe. It opened what was to become La Plata County to mineral development. With the help of Chief Ouray, the agreement was ratified, and peace remained between the two nations, but as was typical of the time, the white settlers benefitted most, and the details of the accord were often broken by the newcomers.

With the Brunot Agreement in place and Euro-American population growth exploding, the Colorado legislature created three new counties from the vast Conejos County in February 1874. These were La Plata, Hinsdale, and Rio Grande Counties.

La Plata was the largest, incorporating the area that today includes Montezuma, Dolores, Rio Grande, and San Juan Counties. The initial county seat chosen was no more than a haphazard collection of shacks and structures known as Howardsville, north of Silverton.

County boundaries in early Colorado history were changed often as new counties were routinely created by the legislature. These changes were typically based on population and terrestrial geography but also, at times, political realities. After Colorado became a state in 1876 and with county government in the Upper Animas mining district struggling to meet the needs of the southern portion of its borders, the new county of San Juan was created, leaving a downsized La Plata County comprised of present-day La Plata and Montezuma Counties. Silverton became the San Juan County seat, and Parrott City, the busy mining town at the foot of the La Plata Mountains, near present-day Hesperus, became La Plata County's.

With the coming of the railroad and the establishment of its base in Durango in 1881, the county seat was moved to Durango following a vote of the citizens. Today, almost nothing of Parrott City exists, and the land is in private ownership.

Finally, in 1889, the new county of Montezuma was created, taking with it the towns of Mancos, Big Bend, Dolores, and Cortez.

Today, within the borders of La Plata County, located in the southwestern corner of the state, is a varied landscape of mountains, forests, high mesas, and farmland. Four rivers of significance traverse the landscape: the Animas, La Plata, Pine, and Florida. Four peaks greater than 14,000 tower over its northern climes: North Eolus, Eolus, Windom, and Sunlight.

There are essentially three separate parallel areas of land ownership in the county. At the southern horizontal edge, bordering New Mexico, are lands predominately owned or controlled by the Ute tribe and its peoples, though there is some private ownership interspersed. The northern perimeter strip is mainly comprised of public land managed by the National Forest Service and the Bureau of Reclamation. The middle horizontal section is chiefly private land acquired through homesteading.

La Plata County is dissimilar from other counties because of its geographical location, varied terrain, natural resources, water volume, and its history of distinctive political will.

The first inhabitants of the area defined by La Plata County's borders were, of course, Indigenous peoples. Their presence goes back a millennium, but today people are most familiar with the Ancestral Puebloan era that ended around 1300 AD. The Ute people are thought to have entered the area around this same time. There have been Navajo (Dine) and Spanish presence in the area since the 1500s but with little permanency until more modern times.

The American government asserted control of the western United States that included this area in 1848. The Colorado Territory was established in 1861. Prior to this time, the southwestern region of the territory was fairly ignored by the white US populace, but that changed when a group of men entered the area in search of mineral wealth in 1860. Known as the first Baker Party, the group of 21 men entered over today's Cinnamon Pass and prospected its northern reaches. Building a settlement they called Animas City, it was about 16 miles north of what was later to become also known as Animas City (north Durango today) and home to possibly 300 inhabitants. It lasted for less than two years. The beginning of the Civil War and the recognition that the mineral wealth would take much more work to be realized than was first thought led to their departure. After the war, the miners returned, and by 1870, mining claims were staked, albeit illegally, as the aforementioned Brunot Agreement was not ratified until 1874.

Ostensibly, to keep peace between the settlers and the Utes, a military post called Fort Lewis was established first in Pagosa Springs and then moved to the La Plata River south of present-day Hesperus in 1880. Whether it accomplished this goal by merely its presence or if it was never really needed is a point of argument. In either case, the intervention of Ute chief Ouray greatly influenced the peace, and no violence of any significance took place between the two groups of people. The post was decommissioned in 1891, and the buildings were converted to an Indian boarding school, the repercussions of which are still being felt and debated today.

The boarding school closed in 1911, with the State of Colorado taking control. In accepting the property in a grant from the federal government, the state agreed to maintain it as an institution of learning and admit Native American students free of tuition. This promise continues today with over 45 percent of Fort Lewis College's student body being Indigenous peoples.

With its economic origins owed to mineral development and the ancillary goods, services, and labor required, the La Plata County economy was also driven by a strong coal-mining industry. Eventually, as mineral development declined in the early 1900s, agriculture assumed a more important role in the livelihood of county residents. Durango became the economic hub of the Four Corners region, and commerce became a leading driver of the economy.

When the local smelter transitioned during World War II from the refining of precious metals to the enrichment of uranium for the Manhattan Project, another facet of county development took place. The economy was strengthened through the early days of the Cold War through the

operation of the smelter by the Vanadium Corporation of America, but its legacy of radioactivity at the tailings pile along the Animas River in Durango had long-term effects on the area that many believe still exists today. Some say the health of the population was affected or at least at risk, but no definitive study ever substantiated those fears.

In the 1950s and 1960s, oil and gas development primed the economic engine, but by the 1970s, tourism had become vitally important to the financial well-being of the area. Today, many things contribute to the county's financial strength. Agriculture, light manufacturing, retail trade, higher education, tourism, and outdoor recreation play significant roles. Many retirees add to the mix as well.

As mentioned, though isolated, to the dismay of some longtime inhabitants, the county is not undiscovered. From a population of around 1,100 in 1880 to the 2023 estimate of 57,000, La Plata County has shown a steady influx of people since its founding. Recently, as the population has rapidly increased, housing prices have risen so high that key workers such as public safety employees, health care workers, and teachers struggle to buy homes within the county. Service workers have it even worse, with many struggling to afford rentals. State, city, and county governments constantly work to address these issues.

Upon its creation in 1874, La Plata County included many settlements that today are outside the county boundaries. Included are Howardsville (the first county seat), Eureka, and Silverton. Until 1889, the county included communities now in Montezuma County, such as Mancos, Cortez, and Dolores.

Some original La Plata County communities no longer exist. Among them are Big Bend (near present-day Dolores), the two Animas Cities, Elbert, La Plata, and the second county seat, Parrott City.

So, while today La Plata County has just three incorporated municipalities—Durango, Bayfield, and Ignacio—it has dozens of geographical communities. These include Allison, Bondad, Breen, Kline, Gem Village, Hermosa, Hesperus, Marvel, Mayday, Oxford, Purgatory, Redmesa, Rockwood, Tiffany, and Vallecito.

In the pages that follow, through historical images, the reader may get a sense of the county's remarkable range of resources, both natural and man-made. They may also come to get a new perspective on its people and the communities that have made the county a unique and enjoyable place to live.

A renowned 1950s Hollywood director said, "Life is lived in color, but black and white is more realistic."

Hopefully, these black-and-white photographs from the archives of the La Plata County Historical Society will bring that reality to life. Enjoy them in all their glorious grayscale.

One

COMMUNITIES AND
INDIGENOUS PEOPLES

Parrott City, shown here in a drawing by mapmaker Emil Fischer, was the second La Plata County seat. Upon the county's creation in 1874, Howardsville, near Silverton, was first. When San Juan County was created in 1876, Parrott City became the seat of government, and by 1881, the new town of Durango took over. Today, nothing is left of this community that sat at the mouth of La Plata Canyon.

Animas City, established in 1876, pre-dated Durango by four years. People had settled on what was later to become the townsite by 1874. Established as a hub for the farmers and ranchers of the Animas Valley that supplied food to the high-altitude mining camps to the north, it enjoyed an early economic success. Seen here in an 1897 photograph from the US Geological Survey (USGS), the view is looking southeast.

This early view of Animas City looking south toward Durango can be dated to between 1898 and 1904. The fairgrounds with its distinctive oval racetrack and the wooden grandstand, built around 1898, can be seen in mid-picture. Just south of the fairgrounds, the line of trees running horizontally across the photograph outline the path of Junction Creek as it winds toward the Animas River.

This photograph by the USGS in 1897, taken from today's Fort Lewis College hill, is looking north toward Animas City. The fairgrounds with its original grandstand can be seen in the middle right. The row of trees transecting the middle of the picture line Junction Creek, the accepted borderline between the towns of Durango and Animas City. St. Columba Catholic Church is prominent in the middle left.

Taken in 1918, this photograph is somewhat unusual in that it is looking easterly. Most photographers used Reservoir Hill in the distance to get a panoramic view of the town while looking west. In this picture, the newly completed high school and the 1891 county courthouse are most prominent across the upper edge of the downtown district. The railroad right-of-way can be seen just above the row of houses on the left.

This early view of Durango looking toward Smelter Mountain shows Sixth and Seventh Avenues with most residences still having areas for keeping livestock in town. The twin smokestacks of the Durango Smelter were going strong. Probably taken at the turn of the 20th century, this photograph illustrates how much open property still existed on the eastern edge of the town. Park School, built in 1899–1900, is visible on the left.

Third Avenue in Durango was a muddy mess when this picture was taken around 1910. The boulevard trees were growing well, and sidewalks were installed, but paving of the street did not occur until the 1930s. Early Durango planners envisioned the primary streets of the town to be Main Avenue for retail trade, Second Avenue for wholesale trade, and Third Avenue for high-end residences and churches.

The photographer was standing in front of the Strater Hotel when taking this image looking north up the 700 block of Main Avenue around 1908. Jackson Hardware is the building advertising Buckeye Mowers on the right. The Topic Saloon at 723 Main Avenue is seen on the west side of the street, operated from 1904 to 1913.

Taken in Rockwood before 1916, this photograph shows the Buchanan sisters Ruby Fry (left) and Nettie Grabowsky (right) with their husbands and friends on an outing along the wagon road that passed through the community. These two daughters of Andrew Buchanan are presumed to be the women on horseback enjoying refreshments from the bottles.

Looking north up the Animas Valley toward Hermosa, this image shows the undeveloped valley in the late 1890s. This image was taken from the low hill separating Falls Creek from the Animas Valley at the Wigglesworth Waterfall Ranch. Close by, important Basketmaker II archeological sites were excavated in the 1930s. Hermosa Creek enters the valley in the middle left. Fruit orchards were prevalent there.

Carson Ranch was a stop on the wagon toll road leading to Silverton from Animas City. When the railroad began building the line to Silverton in 1881, it became known as Rockwood, a staging area for the builders as they entered the upper Animas Valley. A small depot (far left) was established, and Rockwood became the last place on the line that could be accessed via roads before reaching Silverton.

Hermosa was the center of the county fruit-growing industry due to the warmer winds that tend to flow down the Hermosa Creek drainage. The Buchanans were successful orchardists who shipped 3,500 boxes of Wagner apples in 1905. Kittie (left), married first to Alfred Turner, son of Baker Party member John C. Turner, married Andrew Buchanan (right) in 1910, after her first husband's death in 1904.

The Baker Party, who first entered the Animas River Valley prospecting for gold and silver in 1860, built a bridge at this rocky narrowing of the river canyon. The log and timber bridge shown here came later, along with the wooden dam seen directly upstream. This bridge was wiped out in the 1911 flood and has been rebuilt and relocated twice since this photograph was taken.

This is the John Conley Ranch next to Bakers Bridge around 1885. Conley homesteaded the property, making it the base of his freighting operation. It was located just to the west of the Animas River, very near to where the Baker Party built the first Animas City in 1861. Although he lost many buildings and crops to a fire around this time, Conley rebuilt successfully.

Electra Lake, originally known as Cascade Reservoir, is located 23 miles north of Durango. It was constructed in 1902–1903 to hold water delivered by a flume from Cascade Creek. Another flume was built for transporting its water about 1.8 miles to a steep incline above the Tacoma Power plant located alongside the Animas River. Water enters the power plant through a large pipe, spinning turbines for electricity generation.

Hesperus, shown here in 1890, originally provided support to the nearby Fort Lewis military post established in 1880. Later, its economy was driven by its role as a coal-mining camp for the Porter Fuel Company's Hesperus Mine that opened in 1892. The Rio Grande Southern Railroad located a water stop and station there in 1890. The Hesperus Post Office was established in October the following year.

This is the mill located near the community of Mayday at the mouth of La Plata Canyon. The town and working mill served the nearby mines. The Mayday Mine opened in 1902 producing mostly gold and silver. It closed in 1942. It is still thought to have abundant mineral wealth. Even as late as 2019, efforts were made to resume mining. The community still exists along County Road 124.

Opened in 1901, the Southern Ute Indian Boarding School at Ignacio operated until 1920. Like other Indian boarding schools, it attempted to assimilate American Indian youth and eradicate their culture. This purpose, now condemned, has left a negative legacy that is still felt today. After 1920, these buildings continued to serve the tribe intermittently as schools, with the last classes held in 1956.

The Hans Aspaas Mercantile was an early anchor in the Ignacio business district. Incorporated in 1913 with Aspaas as one of its founders, Ignacio has always remained a tri-cultural community. These people were on a promotional tour for the town with a banner advertising "Ignacio Colorado." This store, pictured around 1915, burned in 1917. Hans's father was one of the earliest homesteaders in the Animas Valley, arriving in 1874.

One of the first settlements of any size in eastern La Plata County was Pine River. The community, with this post office and store dating to 1878, was located along its namesake river about 10 miles north of today's town of Bayfield. It is estimated that about 100 homesteaders lived there alongside a substantial number of Ute tribal members.

Taken in front of a Bayfield drugstore and barbershop around 1910, this photograph shows early residents gathered downtown on Mill Street. This building still exists. Town founding fathers William Bay and Warren Schiller donated land in 1898 for the townsite. They tossed a coin to determine the town's name. Bay won, and the town was named Bayfield rather than Schillerville.

Proof of human habitation in La Plata County dates back 10,000 years. The majority of archeological sites in the county date from 650 to 800 AD. This range of years encompasses the Basketmaker III and early Pueblo I periods. For four summers in the 1960s, amateur archeologist Homer Root led Fort Lewis College students in excavations in Ridges Basin, leading to a more contemporary period of archeological study in the county.

Ridges Basin was a natural farming area for the Indigenous inhabitants. The basin is located just west of today's Bodo Industrial Park and southwest of Smelter Mountain. Some of Root's finds are considered significant and include five large Basketmaker III pit houses and numerous pots and artifacts. This is a Homer Root–led pit house excavation taking place in 1966. Many of these excavation sites are now covered by Lake Nighthorse.

Regarded as one of the greatest Native American chiefs, Chief Ouray, seen here in 1875, was a key negotiator for a number of agreements and treaties with the government. A peacemaker and advocate of the Ute people, he worked to ensure his people's rights and freedoms. He was revered both during and after his lifetime (1833–1880). Regrettably, many parts of the treaties were broken by the government.

This is one of three photographs taken of the Ute peace delegation of 1868 in Washington, DC, Pictured are Sa-wa-ich (second from left) and Nic-a-cat (second from right) with government officials. Seven Ute bands sent negotiators, including Chief Ouray. The Ute lands on Colorado's Western Slope were greatly reduced by the Treaty of 1868. Violence ensued when the government failed to fulfill the terms of the treaty.

13. Unknown 12. A-ca-tash 11. Col. Boone 10. Gov. Hunt 9. Ute Jack 8. H.P. Bennett

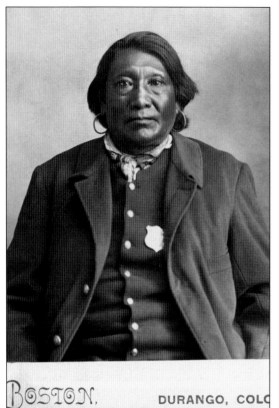

In the 1880s, the Southern Utes consisted of the Weeminuche, Muache, and Capote bands. Chief Ignacio (1828–1913) was the leader of the Weeminuche. In 1880, he was part of the delegation that traveled to Washington to testify about the 1879 Meeker Incident. Although his group was not involved in that violence, Congress nonetheless forced them onto reservations, with the southern bands remaining in Colorado.

Likely taken at Durango's Pen-Dike Studios, this photograph shows Chief Ignacio (seated left) with seven fellow Ute tribal members around 1905. The Euro-American shown in the first row to Ignacio's left wearing a clerical collar and holding a Bible or prayer book is believed to be local priest Fr. John Duffy, rector of Durango's St. Columba Catholic Church. Only Chief Ignacio has been firmly identified in the picture.

Sapiah (1840–1936), also known as Buckskin Charley or Charles Buck, was chief of the Mauche and Servero bands of the Southern Ute tribe. In 1880, he became the principal treaty negotiator after Chief Ouray's death. Along with Chiefs Ignacio, Severo, and Tapuche, he presided over many difficult negotiations with the government in which he tirelessly advocated for his people. He lived to be 96 years old.

Along the Pine River in an encampment near Ignacio before 1912, this group wears traditional dress for the ceremonial event taking place. In this photograph taken by Frank Gonner, Southern Ute chief, Buckskin Charley (also known as Sapiah), is fifth from left. Chief Severo of the Caputa band stands next to him on the right. Emma Buck, Charley's wife, is the woman with long hair two places farther to the right.

Sapiah, or Chief Buckskin Charley, had two sons. Both exhibited the leadership qualities of their father. The older, Julian, shown standing, died at the age of 38 in 1904. His brother, Antonio, went on to succeed his father as hereditary chief of the Southern Ute tribe and then became its first elected tribal chairman. He lived to 91, passing away in 1961. Both are interred in Ignacio's Ouray Memorial Cemetery.

Ute chief Charles Buck (Sapiah or Buckskin Charley) maintained an adherence to Ute traditions throughout his long life. He was not, however, opposed to adopting tenets of white culture. He championed education for his people so long as it could be received at home on the reservation. Passing away in 1936 at the age of 96, he remained active in tribal affairs throughout his long life.

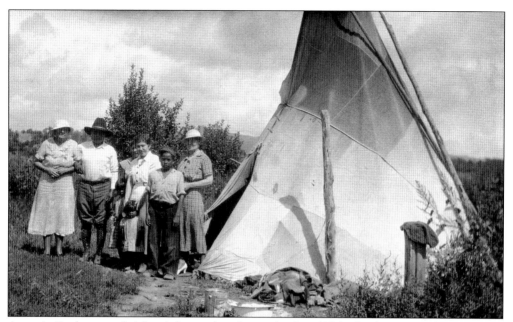

Antonio Buck succeeded his father as hereditary chief in 1936, also becoming the first tribal chairman that same year. Here, with his wife, Juana, and their children, he is shown welcoming visitors to their camp and teepee near Ignacio in 1938. Chief Buck served as chairman until 1940 but retained his hereditary tribal chief status his full life. He died in 1961 at the age of 91.

This is thought to be the H.L. Hall Trading Post at the Ute Agency near present-day Ignacio. It served as a gathering place for Ute tribal members and non-Ute inhabitants of the Lower Pine River in the early part of the 20th century. Area residents transacted business but also socialized. Here, a group of Southern Ute tribal members pose with other citizens of the area in 1909.

The Southern Ute people have retained their cultural identity throughout the modern era. It has been customary for them to wear and be photographed in traditional and ceremonial dress since the 1870s. Here, three young tribal members proudly pose around 1900 near the Ute Agency.

Chiefs Ignacio and Sapiah (Buckskin Charley) established lasting friendships and cooperation with the non-Ute peoples of La Plata County. Their example served to strengthen the shared cultures of each and foster understanding. This photograph shows Anglo and Ute women socializing at the Ute Agency in Ignacio sometime around 1900.

At the turn of the 20th century, wagons were the primary means of transportation in La Plata County. Here, a group of Southern Ute women and children are gathered around their wagon near Durango. The people on the left are presumed to be Durango citizens looking at Native American goods for trade or purchase.

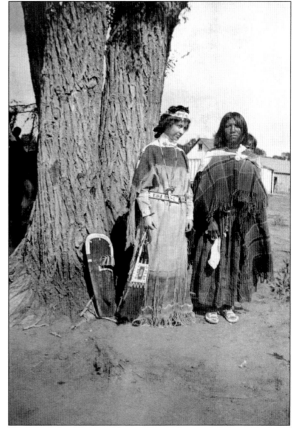

Cultural exchanges between Indigenous peoples and their Euro-American counterparts in La Plata County were customarily a two-way street. In the early 1900s, it was not uncommon for Anglo women to adopt native dress for certain occasions with the help of their Ute friends. A young local Ute woman and her child are shown here with a young non-native woman wearing traditional Ute clothing.

Concerned that the remains of Chief Ouray, who died at the Ute Agency in 1880, would be exhumed and moved to Montrose, Chief Sapiah and other tribal members arranged to have the great chief's remains disinterred and reburied in the Ignacio Ute cemetery (now known as Ouray Memorial Cemetery). To honor the chief, they held a three-day ceremonial event and fiesta from May 22 to 24, 1925, in conjunction with the reburial. Thousands attended, including many from nearby tribes as well as non-natives. Traditional Native American sports, contests, dances, and ceremonies were held. These pictures show the formation of the funeral procession prior to the traditional ceremonial reinterment. The Pathé film production company was purported to have captured the event for its popular newsreel program. The men in business suits shown here are likely part of the production team.

Fairs in La Plata County have always been very popular. Held at the fairgrounds starting around 1896, these fairs and fiestas typically included events featuring Native Americans. This Southern Ute tribal member is waiting to display his riding skills in one of the popular demonstrations of the 1900 fair program. Animas Mountain can be seen in the background.

Photographer F.J. Will took this image of Southern Utes on parade in front of the old Durango High School on Twelfth Street in the early 1940s. Staff at the Southern Ute Cultural Center and Museum believe that Antonio Buck Sr. is on the smaller horse, second from right. The tribe had a major presence in all fairs and fiestas from the 1890s through the 1980s.

Cradle boards were a source of pride for Ute women. They served to both protect the infant and as a means of transporting children either on foot or horseback. They were usually decorated ceremonial gifts made for the new mother by relatives and constructed prior to the baby's birth. This mother, child, and infant are at the fairground's track preparing to watch a horse race in 1900.

La Plata County around Hesperus Peak in the La Plata Mountains is considered the traditional homeland (Dinétah) of the Navajo (Diné) peoples. Pictured here is a group who have traveled to a Durango studio to have their portrait taken in 1890. Though not a part of the modern Diné reservation, located adjacent to Colorado in New Mexico and Arizona, La Plata County has long enjoyed a favorable relationship with the tribe.

Two

AGRICULTURE, COMMERCE, AND INDUSTRY

The high elevations surrounding the mines in the upper Animas region around Baker's Park (Silverton) were not conducive to growing food crops. The lower Animas Valley, shown here, became the county's agricultural center for providing food and livestock to the miners and residents of the mining districts to the north.

Stock raising became important to the county economy. By 1878, ranches were established around Bayfield and Ignacio. Here, Hatcher-Dyke cowboys are shown around 1880 with the HD Mountains in the background. The low mountain range located east of Bayfield encompasses an area from Chimney Rock to the New Mexico border, including a swathe of Southern Ute tribal land. The range took its name from this ranch, located at its eastern edge.

Ridges Basin, located just south and west of Smelter Mountain, was farmed as early as the 1880s. Without a reliable water source, it struggled to provide consistent crops. Here, contractor J.W. Morgan is using horse teams and wheel scrapers in a first attempt to create a reservoir there. A permanent reservoir was finally achieved when Lake Nighthorse was completed and filled with water in 2011.

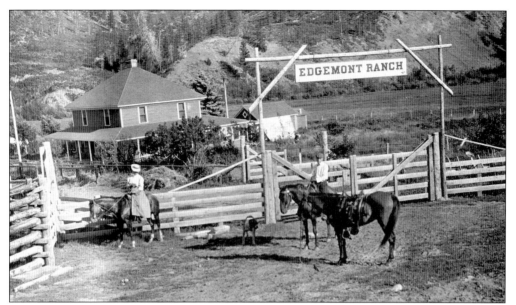

Edgemont Ranch was established around 1905, about 10 years before this image was made. The 1,400-acre ranch had at least five owners throughout its agricultural history but was sold in 1981 to a development company based in California for over $5 million. The company's plan for constructing residential subdivisions was subsequently approved. Today, it is part of the large Edgemont housing development located along Florida Road northeast of Durango.

Sheepherding was never the economic force in La Plata County like it was in surrounding counties of Montezuma, Dolores, San Miguel, Archuleta, Hinsdale, and San Juan. The sheep from these other counties were typically shipped through Durango on the Denver & Rio Grande Railroad or the Rio Grande Southern Railroad. Here, sheep are prepared for shipping by dipping in troughs containing pesticides to prevent the spread of parasites in the flock.

Churchgoers rode horses to services in Durango for many years, even after the coming of the automobile. Here, the equines wait patiently for their owners who are attending services at the Methodist church on Third Avenue sometime in the 1890s. The boulevard made an ideal place for tethering horses along the city street.

Cattle, horses, and other farm animals were allowed to be kept within the city limits of Durango until 1957, though complaints of the smell, noise, and potential health hazards were voiced as early as 1895. This herd of cattle is being driven through the east 300 block of Eleventh Street, a residential area just east of downtown around 1916.

Tom and Nora Robertson homesteaded about six miles east of Ignacio and eight miles south of Bayfield. Here, the family is shown in the early 1900s at their ranch. Their children are, from left to right, Bert, Harry (being held by Nora), Dorothy, Gordon, and Della. Tom is standing between Gordon and Della.

Beaver Creek traverses the countryside northwest of Bayfield, emptying into the Pine River just south of the town. Here, Otis Snooks Sr. is seated on a reaper binder pulled by three horses at his property on Beaver Creek around 1900. Today, the Beaver Creek Ranch development is located in this area, about five miles from downtown Bayfield.

Getting water to the fields in the county was important yet challenging. Ditch and canal construction has been ongoing since the first fields were cultivated in the 1870s. Here, work is being done on the Reese ranch's west lateral canal on the Florida Mesa. Horse-pulled scrapers were used in this early-1900s effort.

Though not known as a large timber-producing area, La Plata County has had many sawmills through the years. Thomas Graden established one in Rockwood to supply ties for the first railroad construction. Other mills were located at Falls Creek and along both Lightner Creek and the Pine River. The Bowman sawmill was in Ridges Basin. This steam traction engine is hauling logs in the county around 1905.

J.W. Morgan (left) and Sam Hood (right) rope horses for branding in this photograph from 1900 on Morgan's ranch. Morgan was a well-known and longtime county horse rancher. He was also involved as a construction contractor for the first Ridges Basin reservoir in the early 1900s, where Lake Nighthorse is now located.

Ed and Marie Bluck introduced their children to horses early. In 1909, Ross Bluck, age four, and his younger brother Art, age two, are shown with their parent's horse near their property in Hesperus. The Blucks variously owned the Strand, Gem, Rialto, and Kiva theaters in Durango in the 1920s and 1930s. Ross went on to a 20-year career working for RKO and Columbia Pictures.

These two La Plata County residents were caught on camera resting in a cornfield on a farm presumed to be on the Florida Mesa. Farming experienced a period of growth in the county with the rise in commodity prices after World War II. There were around 1,000 farms countywide with an average size of 640 acres at the time this photograph was taken in 1945.

Located in the Vallecito area, the Teelawuket Ranch was homesteaded by brothers Charlie and Joe Graham in 1886. Sold to oilman Johnny Kirkpatrick eight years later, it eventually was converted to a boy's camp in the early 1920s and then to a guest ranch in the early 1950s. Here, Kirkpatrick is seen in front of the ranch house in 1900.

La Plata County quadrupled its acreage under irrigation between 1900 and 1910, when this photograph was taken. Going from about 10,000 acres to over 40,000 acres was a substantial improvement. The first thresher was used in the county in 1877, and by the time this Case mechanized thresher was in use, the technology had paid big dividends in production for local farmers.

The Bodo family moved to Ridges Basin in 1912 and slowly acquired property in the area where they farmed and raised cattle. Much of their property is now where Lake Nighthorse and the Bodo Industrial Park in Durango are located. Here, Ron Bodo, at the age of five, is seen sitting on a tractor as it drives a thresher drive belt on the farm in 1944 or 1945.

Members of the Grice family are shown with their combine and tractor on their Florida Mesa ranch in the 1930s. George Grice came to La Plata County in 1921 and was a well-respected farmer, minister, and photographer. He farmed on the mesa and also in the Animas Valley. He died at the age of 73 in 1940 and was survived by his wife and six daughters.

At 1:30 every Thursday afternoon for 42 years, the place to be for many of La Plata County's ranchers and farmers was the auction barn at the Basin Livestock Commission. Located where the Home Depot is today, the sale barn was a place for agricultural people to conduct business, get a meal, and enjoy its lively rural social scene.

For many rural county youngsters, the August county fair has long been the high point of their year, as the event served as the culmination of their efforts to grow prize-winning livestock. Starting in the 1940s, the well-attended youth stock show at the fairgrounds was always a fan favorite. Businesses throughout the county provided financial support by means of the annual livestock auction that followed the judging. Here, two events from the 1959 fair are being conducted. Various animals are being shown within the horse track in front of the rodeo arena in the above photograph. Below, steers are being judged at the southern end of the grounds near the livestock barn.

La Plata County's initial economic development was driven by mining. Nothing was more important to the metal extraction industry in southwestern Colorado than the New York and San Juan Smelter. It opened in 1882 and is shown here around 1915. The Denver & Rio Grande Railroad built into the area predominately to access the surrounding mining districts in order to transport ore to this smelter, thus ensuring its financial future.

Precious metal mining was the impetus for the early settlement of the county in the 1870s. As the mining fortunes turned, so did the general economy of La Plata County. Silver was the predominant metal in the early years, but with the silver crash of 1892, operations were curtailed, and gold became the dominant metal. The Gold King Mill in La Plata Canyon served the biggest producing mines.

The Lucky Discovery Mine opened in 1909 when John Wheller noticed an unusual looking outcrop of rock on a hillside in La Plata Canyon. It proved to be laden with gold, and mining operations commenced soon thereafter. The mine was worked continuously until World War I and then intermittently until 1936. Here, 12 miners gather at the mine's adit for a photograph in 1933.

Early La Plata County's establishing economy could be considered a three-legged stool, with first, mining to attain the raw material; second, a smelter for recovering the precious metals; and the third leg being the means of transporting the ore to the smelter. The Denver & Rio Grande Railroad provided that function from nearly the beginning, starting in 1881. Due to reorganizations and mergers, it became known as the Denver & Rio Grande Western Railroad (D&RGW) in 1921. In 1981, with new ownership, the name was changed again to the Durango & Silverton Narrow Gauge Railroad (D&SNG). Here, the railroad yard and roundhouse in Durango are pictured around 1952.

This is a view of the Denver & Rio Grande Western Railroad's Durango rail yard in 1946. Note the coaling and water towers that no longer exist. The yard shows the prevalence of freight cars that were once used as the primary means of profitability for the railroad before transitioning to a passenger tourist-centric business by the 1960s.

Coal was critical for La Plata County from its infancy. It provided domestic fuel for warmth, coal oil for light, fuel for railroad engines, and perhaps most importantly, energy for the smelting process of precious metals. The county has had dozens of mines over the years, providing thousands of jobs. These are Boston Fuel & Coal Company miners from the Perin's Peak coal mine entering the mine around 1920.

Just to the west of the Durango Smelter, the large mine of the San Juan Coal Company provided coal both for the train and for the coke ovens located nearby. Coke is a coal-based fuel with a high carbon content with few impurities, made by heating coal in the absence of air. The smelter used coke for its processes. Here, 11 miners are shown at the mine tipple around 1920.

Timber was a plentiful natural resource in the county. The first sawmill operated near La Plata Canyon to provide timber for the mining industry in 1876. Most sawmills were small in scale and provided milled lumber for building construction. Some larger operations provided ties for the railroad and timber for mining. This is the Nelson Sawmill located near today's turnoff to Lemon Dam from County Road 240.

The Weidman Sawmill was the largest operating lumber mill in the county. Originally located along the Piedra River, it was moved to this location south of Durango along the Animas in 1946. Adjacent to the Denver & Rio Grande Western line, it utilized a spur for shipping lumber to market. At its height of operation in 1960, it employed over 100 people. By the early 1980s, it ceased operations and was dismantled.

Thomas Graden was one of early La Plata County's most successful businessmen. He owned a number of sawmills, a slaughterhouse with feedlots, a flour mill, a coal mine, an electric company, a mercantile store, a machine shop, a foundry, and a streetcar company. This feed mill of Graden's was located between today's Double Tree Hotel and Albertsons, at the western terminus of College Drive in Durango.

Located adjacent to the railroad depot, Durango Iron Works was an important early provider of metal and foundry products for the railroad and mining industry. These are the company's buildings in 1895, located where the Gaslight Theater is today. By the turn of the century, it was known as the Durango Foundry and Machine Company. It eventually became Telluride Iron Works, which still exists, at least in name, today.

In the 1890s, oil and gas drilling came to La Plata County. Throughout the 1920s and 1930s, sporadic drilling and production occurred, but with only minimal crude oil shipment via railroad, the industry languished. A Mc-Gar Petroleum Corp. derrick is shown in the southwest portion of the county in 1934. In the mid-1950s, a true "gas rush" came when the county was connected to California and other markets via pipelines.

With the railroad locating its station there, Durango early on became the commercial hub of the county and region. Its downtown was vibrant with a wide range of businesses. This 1892 photograph shows the Ricker Block (today's west 1000 block) of Main Avenue. From left to right are Ricker Fruit & Confectionery, Schnee Barbershop & Baths, B-Kerns Saloon, Delmonico Restaurant, Five & Ten Cent Store, and Star Bakery.

Also from 1892, this photograph shows the west 1100 block of Main Avenue with its two anchor businesses, both owned by W.C. Chapman. This brick two-story building at 1129 Main Avenue still exists and is unmistakable today with its three arched windows with light-colored triangular accents on each. It is located next to the culinary collective, Eleventh Street Station.

Saloons, bars, and taverns were a mainstay in the county, especially downtown Durango. This 1905 photograph shows patrons both imbibing and gambling at the El Moro. Illegal wagering at this and other establishments eventually led to a shoot-out between the town deputy marshal and the county sheriff, who died of his wounds. Jesse Stansel, standing on the left with a mustache, is the deputy marshal who survived, though barely.

As an area-wide supply and provision center, Bayfield had a thriving business district in its early years. This is the B&W Grocery around the turn of the 20th century. Though a bank was established in Bayfield in 1910, it only stayed open for 20 years before the Great Depression counted it as one of its victims.

Until the late 1940s, area grocery stores were mostly mom-and-pop operations. Chain stores Safeway, Piggly Wiggly, and City Market arrived with greater pricing power causing many of the locally owned stores to close by the 1960s. Here, the staff of Wahler's Grocery are shown in 1949. Located in a prime downtown location at Sixth Street (today's College Drive) and Main Avenue, Wahler's was out of business by 1959.

As the automobile became more prevalent and the roads leading to southwest Colorado improved, tourism and passenger transportation services beyond just the railroad grew in acceptance. Here, the driver of the Cannon Ball Transport Company bus seems to be considering a car with passengers that has jumped the curb. Durango's Strater Hotel, always a leading place to stay for travelers, is in the background.

Located just north of the Main Avenue bridge on the east side of the 1600 block of Main Avenue, the Brennan Lighthouse Texaco exemplified the competitive gasoline business in the 1920s. Besides providing petroleum and other automotive products, it also had a "curb service" barbecue restaurant called the Blue Pig located in the building. Erected in 1923, the business was demolished in 1949.

Though organized in September 1880, Durango's main thoroughfare through downtown was not paved until 44 years later in June 1924. Thought to be the first paved street in the county, residents were delighted not to have to navigate the muddy quagmire after every rain or winter snowmelt. This photograph shows the progress being made by the Strange-Maguire Paving Company between Eighth and Ninth Streets.

The Denver & Rio Grande Railroad that drove the creation of Durango is today the Durango & Silverton Narrow Gauge Railroad. Tourism saved the line to Silverton from being abandoned. The railroad discovered its sightseeing potential in the late 1940s and constructed the Silver Vista, a domed observation car. It ran for six years before being destroyed by fire in 1953. A reproduction now runs on the line.

In many respects, the train still drives the regional tourist economy with its year-round schedule either to Silverton or Cascade as well as the extremely popular Polar Express holiday excursion train. Livestock hauling, like this train entering the Animas Valley in 1946, is not part of the profit picture today. Hauling wide-eyed vacationers is the focus now.

Three

DENIZENS AND DIVERSIONS

Bill Beecher (center, holding rod) was typical of early La Plata County workers. Foreign-born, he stood only five foot, five inches. Originally a soldier at Fort Lewis, he was discharged in 1887. After being married in Ohio, he drifted back to Durango, gaining employment at the smelter. He is shown here around 1900. Unfortunately, like others in the industry, he died from chronic arsenic exposure at the age of 43 in 1905.

Early La Plata County miners Oliver Holmes and Thomas Raley are shown at Parrott City in 1881. Baldy Peak is in the background. As county seat, it was the center of the southern mining district starting in 1874. It thrived for a short time, reaching a peak population of 250 in 1885. It was all but abandoned within a decade of Durango assuming the county seat designation in 1881.

The Animas River has long been a source of recreation and leisure for the citizens of La Plata County. Fishing and picnicking were the earliest forms of recreation, though rafting and kayaking have supplanted them as the most popular activities today. This is a group out for a holiday get-together on July 4, 1902.

These are students and teachers at Animas City School around 1894. This school was located on the southeast corner of today's Thirty-First Street and West Second Avenue. It was the third school built in Animas City. Today, Mountain Middle School is located at this site. Across Second Avenue, the fourth Animas School was built in 1904 and is presently the home of the La Plata County Historical Society's museum.

When the Smelter Trust (a group of Colorado smelter businesses) cut wages due to a mandate by the Colorado legislature requiring a maximum eight-hour work shift for employees, the labor force immediately went on strike, idling 5,000 men. In this 1899 photograph, a group of clerical workers are pictured as they assumed laborer duties in order to withstand the strike. The union-led work stoppage was only partially successful.

These images, taken during an early springtime excursion, show family members and friends of the Mollette family in the Animas Valley just north of Durango. Missionary Ridge is in the background. This day trip included travel by both horse and buggy and automobile and is thought to be from around 1917. Rex Mollette was a La Plata County attorney with a thriving law practice in the first three decades of the 20th century. He was also an accomplished amateur photographer and is presumed to have taken these photographs during a family outing. Using the nitrate negative method of photography, his photographs are some of the clearest available from that era today.

Taken in an unknown location within La Plata County around 1905, this photograph of Robert Dwyer Jr. on the burro and his brother Joseph on the right, with two other local children, illustrates the popularity of burros as a means of transportation in the first 30 years of the county's existence. Photographs of children as well as adults astride these beasts of burden are common in the historical society's archive.

This railroad survey crew took time out from their work in the summer of 1900 to swim in the Animas River in the area known today as Twin Crossing. Under the direction of Thomas Wigglesworth, they were surveying for possible railroad routes to the south for transporting coal. Wigglesworth was the renowned locating engineer for the Denver & Rio Grande's construction of its line from Durango to Silverton.

This is presumed to be the C.C. Perkins family around 1918. The children are thought to be Gilbert, costumed as a doughboy Army soldier, and either Marian or Luella, costumed as a Red Cross nurse. The photograph was taken at their home at 1237 East Third Avenue. Their mother, Zaidee Rockwood Perkins, was from an early La Plata County pioneer family. C.C. was involved in banking, lending, and real estate.

The Searcy family had ties to early La Plata County. Helen Boston, daughter of one of Durango's first photographers, married William Searcy in 1879. William served as a judge in the Sixth Judicial District from 1913 until his death in 1932. Here, their daughter Helene is seen standing at the family home at 2455 West Second Avenue surrounded by two friends in the same year her father became judge.

La Plata County's ethnic population has always been diverse. People of Native American, Hispanic, and European descent have predominated but Asian and African Americans have also called the county home. Some early African Americans were buffalo soldiers first stationed in Colorado. Some Asian settlers originally came with the railroad construction crews. This Durango family, thought to be of Chinese lineage, poses at their property around 1920.

The Durango High School track team of 1914 proudly displays their first-place trophy in this photograph. One student identified in this picture is the young African American on the left, Justin Barnett. He went on to serve his country as a soldier in France during World War I, where he was wounded. Most of this track team also served in the military during the war.

In 1908, these Durango telephone company workers installed the first county telephone lines along the 1100 block of downtown, just east of Main Avenue. Two of the workers are Bert Johnson and E.E. Hoskins, though which two are unknown. Smelter Mountain is in the background. Just above the fence line is the top of today's El Rancho Tavern at the corner of Tenth Street and Main Avenue.

Here, a group of county citizens gathered at the Gem Theater in Durango for an event in 1916. What brought them to the theater for this photograph is unknown, but a close inspection reveals just one woman in the main audience. Located in the structure known today as the Jarvis Building at the corner of Tenth Street and Main Avenue, the Gem opened in 1912 and operated into the 1950s.

W.P. "Billy" Edwards, a Welsh immigrant, was extremely popular in the county. He had a 30-year career with the railroad until the train he was engineering hit a cow near Arboles and derailed. He was pinned in the wreckage and succumbed to his injuries. Over 100 of his friends went to Chama to accompany his body back to Durango for the funeral, shown here in 1917 at St. Columba Catholic Church.

Taken in 1915 by a professional, this photograph shows about 60 schoolchildren in the field house of the old 1892 Durango High School located in the 1200 block of East Third Avenue. The pageant's theme was patriotic, as the piano and some of the students on the left were draped with American flags. What the peaked hats on the boys in the back represented is unclear.

One of La Plata County's most iconic residents was Olga Little. Starting in 1909 at the age of 26, she began her career of running burro pack trains into the La Plata Mountains for numerous mining operations. In 1912, she rescued 18 starving miners stranded in heavy snow. She continued packing until the mines closed in the 1940s and passed away in 1970 at the age of 85.

Summer holidays are a time-honored pretext for county citizens to explore and enjoy the outdoors. Campgrounds and forests today are always full of summer revelers celebrating Memorial Day, Independence Day, and Labor Day. Here, a group of young people are shown relaxing and otherwise having a good time on July 4, 1900, at the still-popular party venue of today, Baker's Bridge.

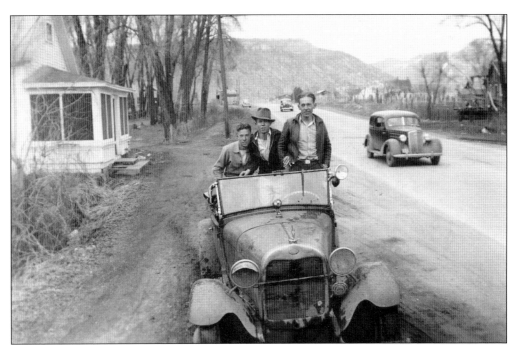

When this 1938 photograph was taken of Don Milton Deluche (center) and the two Conway brothers, the borderline between Durango and Animas City was about three blocks behind them. Their car sits just north of where Junction Creek crosses the 2300 block of Main Avenue. Today, Durango High School is located on the east (right) side of this street, also known as US Highway 550.

Hollywood stars Janet Leigh and Tony Curtis are shown on the set of *The Naked Spur* in 1952. Leigh, famous for her role in the Alfred Hitchcock film *Psycho*, was one of only five actors in the film shot entirely outdoors near today's Purgatory Ski area. Curtis, though not in the film, accompanied his wife to Durango for the location shoot. The couple are the parents of actress Jamie Lee Curtis.

This 1956 photograph of marble tournament participants illustrates the diversity of La Plata County's recreational program in the 1950s. Pictured are, from left to right, David Bell, Dolph Kuss (program director), Leon Turnell, Pete Phillips (Veterans of Foreign Wars sponsor), and Larry Martinez. A jacks tournament for girls was also offered. Kuss made sure every county youngster could participate in the recreational programs at no cost.

La Plata County is blessed with numerous outdoor activities. Fishing is a pursuit that early settlers regarded as a necessity as much as a leisure activity. All county waterways once teemed with fish. Today, rivers and lakes are stocked with fish from the Durango Fish Hatchery, created in 1903. It is the oldest state-owned fish hatchery in Colorado. The boys shown here are fishing the Animas River in 1899.

Electra Lake was created in 1902 when a flume to deliver water to the Tacoma Hydroelectric plant was built, diverting water from Cascade Creek to a basin 21 miles north of Durango. Here, people are fishing from the dam after construction. A sporting club was formed in 1910 with Rex Mollette as one of the organizers. An accomplished amateur photographer, he is presumed to have taken this shot.

A fishing competition for children aged 14 years and younger was started in 1955 with the advent of "Huck Finn Day." Organized by the county recreation department, the event drew hundreds of kids from throughout the county each August. Its 12-year run was sponsored by the Veterans of Foreign Wars and local businesses. Huck Finn Pond was created adjacent to the Durango Fish Hatchery along the Animas River.

Every season provides its own forms of leisure entertainment. Here, seven skiers in 1920 are pictured at Animas City. Skis were then commonly called "snowshoes" and were mostly used to traverse over fields of snow, rather than being used for what today is known as downhill or alpine skiing. Just one long pole was used for momentum. Fred (far left) and Marguerite Clark (behind man with back turned) are pictured.

Another photograph from around 1920 shows a phenomenon surprising to residents today. The Animas River routinely froze enough for skating in its meandering course above Durango in the valley. Ice skaters were known to sometimes skate from the Thirty-Second Street bridge all the way to Trimble Lane during the frigid winters that occurred in the early 1900s. The photographer is thought to be Clarence Smith.

Snow sports have always been very popular with county youths. These young people are preparing to sled down a hill in Animas City in the 1930s. Elizabeth Clark (right) is the seated on a sled. The others, while not identified, are presumed to be siblings and friends. The in-town sledding hill at Third Avenue was not developed until the 1940s.

Dolph Kuss arrived in La Plata County in March 1955 to assume duties as the county recreation director. Within one week he was leading high school skiers to a ski meet in Climax, Colorado. These eight skiers standing next to Kuss are likely from that team or the following year's team. Kuss, from Leadville, was an accomplished Olympic-level ski racer. He competed for Western State College during his college career.

Swimmers Hon Brown and Dorothy Malot are shown alongside the Animas River in the 1930s. Besides being a suitable fishing stream and a place to ice skate in the winter, the river served as a swimming venue for hearty county residents looking for a convenient in-town location. Rafting had not yet become a particularly popular activity on the waterway when this photograph was taken.

Another Dolph Kuss–initiated program was the reutilization of the indoor pool at Durango High School. Mostly unused for over a decade, the pool, initially constructed in 1916 and reconstructed in 1927, was revived again in the 1950s. County children could now learn to swim without the obvious dangers associated with area rivers and lakes. Here, a class of beginning swimmers are getting their first instruction in 1958. Bobby Horvat is the swimmer closest to the camera.

Wherever ranchers and farmers gathered, impromptu rodeo events were commonly held. This bareback ride in the 1920s took place either in Bayfield or Ignacio, as the exact location is unknown. Often prizes were awarded, and many local cowboys competed as a form of recreation, utilizing the skills they needed daily in their working ranch life.

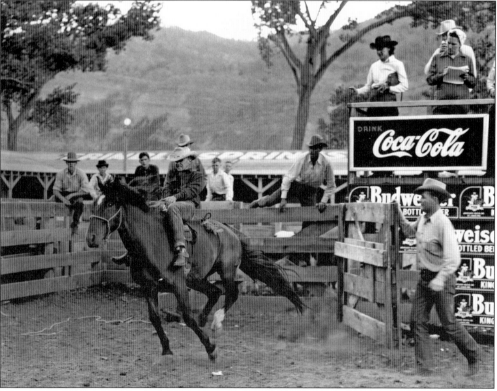

Rodeo has a special place in the minds of La Plata County's rural populace. Besides the rodeo arenas in Durango, Bayfield, and Ignacio, there was, for a few years, a very popular weekend rodeo held at the Trimble Hot Springs Resort in the 1940s. This Animas Valley venue was added along with stables for the resort's dude ranch business. Here, a local cowboy begins his bronco ride.

Traditionally, baseball has been the most popular team sport in the county. Almost all communities of any size have fielded a team at one time or another. At times, teams brought in "ringers" from outside the region to improve their fortunes. Also, "poaching" players from nearby communities was a long-held controversial practice. Here, the Hermosa nine, with their manager, are shown in front of a large Animas Valley haystack.

This is the 1918–1919 edition of the Durango High School baseball team. They are standing at the field in the 1200 block, between East Third and Fourth Avenue. The Mason Center is now at this site. Two of the houses in the background still stand along Thirteenth Street. The coach pictured is longtime Durango school system teacher, coach, and administrator Elza Needham. Present-day Needham Elementary School is named in his honor.

Summer youth baseball in the county was run by Durango native Ward Lee for 42 years. Here, players are receiving instruction from a high school player Lee customarily hired to coach. Parent participation was neither used nor welcomed. There was no cost to the players, with local businesses providing sponsorships to fund the program. An estimated 10,000 players went through the program between 1951 and 1993.

Girls' sports, though not what one may be commonly familiar with today, were still popular for some. This eighth-grade team from the Junior High in Durango is shown in a group photograph surrounding their coach Elvin Cobb. These young women competed in the 1925–1926 season. It was not until Title IX legislation was passed in 1972 that female teams became as prevalent as those of the males.

Little is known about this studio photograph, but it is presumed to be the Durango High School or Durango town football team of 1895. None of the players are identified. Helmets were not worn and did not become commonly used until well after the turn of the 20th century. Football was obviously played much differently when this photograph was taken. The first football game played in La Plata County was in 1893.

Another Dolph Kuss summer recreational program that started in the 1950s was archery. Both genders were encouraged to participate. Taking place at the La Plata County Fairgrounds, this photograph shows the archers taking aim on the football field with the grandstands in the background. The summit of Perin's Peak is visible just above the grandstand roof.

Adults were not left out of county recreational offerings in the 1950s. One of the more popular activities was the weekly square dancing instruction and dance held at either the Smiley Junior High School gymnasium or later at the field house on the campus at Fort Lewis College, as shown here around 1957.

County inhabitants have long enjoyed social gatherings. A passing look at this photograph from 1910 might lead one to wonder, what in the world are they smoking? On closer study, it is evident that this is more innocent than one's first inclination might suppose. These men and women are merely blowing soap bubbles. Enjoying time with friends tended to be quite wholesome in nature.

No historical retrospective of La Plata County could be complete without mention of the region's long love affair with the bicycle. Wildly popular today, bicycling was also quite fashionable around the start of the 20th century. Various cycling clubs existed in the area. Here, the League of American Wheelmen Club from Fort Lewis is shown at the campus in 1900. Men and women were equally represented in the club. Below, Elizabeth Turman is shown in front of her house at 822 East Fourth Avenue in Durango in 1902. Bicycling was more than just a recreational activity for some early Durangoans—it was a means of commuting around town, much as it is today.

Four

PARADES AND CALAMITIES

Woodmen of the World and its women's auxiliary are seen in this photograph taken around 1900. The group is staging for a parade in downtown Durango at the intersection of today's Main Avenue and College Drive. The fraternal organization was quite popular at the time. Functioning as a mutual benefit society, the organization provided funds for widows and orphans should a member suffer an unexpected early death.

Parades give businesses an opportunity to advertise to a large cross-section of the county populace. The Goodman Company was in business for over 100 years. Ray Goodman, the young boy standing in front of this float, was the grandfather of twins Ron and Bill Goodman who were the last of the family to run the business, selling it in 1993.

The county's rural citizens often used the parade venue to showcase agricultural husbandry and farm products. This parade associated with the Colorado–New Mexico Fair was held in September 1919 through downtown Durango. The yoked oxen provided conveyance for the large decorated wagon float before motorized means became the more common method. This photograph was taken at the intersection of Tenth Street and Main Avenue.

The 400th anniversary of Christopher Columbus "discovering" the New World was celebrated throughout the United States. The World's Columbian Exposition, postponed one year, was held in 1893 in Chicago to mark the achievement. The Italian community in La Plata County also held a parade in October 1892 to pay tribute to Columbus's accomplishment. Here, a group of schoolchildren marches down Main Avenue. The caption reads, "Durango Columbian School Parade."

Processions on Main Avenue were not limited to celebratory parades. In 1917, this large funeral cortege of fraternal organizations was held in honor of W.P. "Billy" Edwards. A Denver & Rio Grande Railroad engineer, he was killed near Arboles when his train derailed and overturned after hitting a cow on the tracks. He worked for the railroad for 30 years and by all estimations was very well liked throughout the county.

This is Third Avenue at Tenth Street in Durango in 1910. Parades at that time often looped around the boulevard street as they made their way toward Main Avenue and waiting spectators. Likely an Independence Day parade, a patriotic theme is displayed by every float. In the above image, a team of six white horses pulls a large float draped with American flags. The Fourth of July was the biggest public celebration of the year, and its accompanying parade was unsurpassed until the 1930s when the Spanish Trails Fiesta parade became the preeminent event. The photograph below shows another team of six horses pulling a similarly themed float along the 1000 block of Main Avenue in the same parade. Note the unpaved muddy quagmire and trolley tracks along the parade route.

The McKinney Clothing Company float passes along the west side of the 900 block of Main Avenue in 1922. Businesses along this block during Prohibition were either billiard halls, tobacco shops, or barbershops. Before Prohibition, this "Saloon District" block was a bit infamous, as no "proper lady" would walk on that side of the street. Eventually, by the 1940s, the street transitioned to include more mainstream businesses.

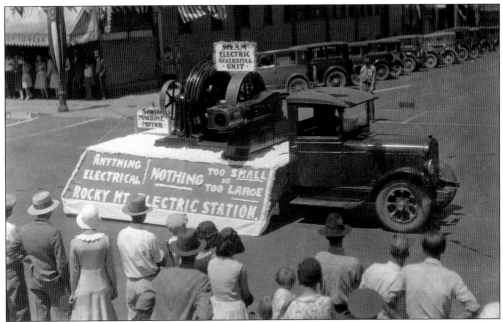

Parades provided a good venue for displaying recent innovations and modern technical improvements for daily life. Here, in 1930, Rocky Mountain Electric Station advertises its ability to electrify most modern conveniences with a portable steam-powered electricity generating unit. Also displayed is an enlarged model of the company's sewing machine motor. This electrical merchandising company showcased a modern exhibit on its float each year.

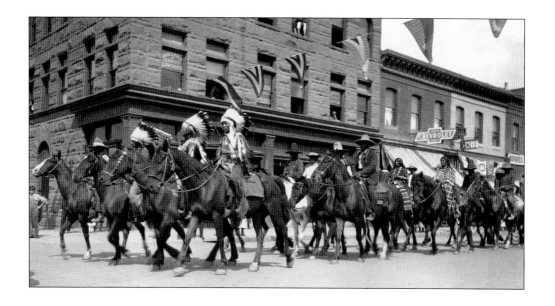

The first county parades included Native Americans. Their presence became especially significant as the years progressed. The area's Indigenous people contributed sometimes as dancers or riders but also as ambulatory participants displaying their traditional clothing and cultural accessories. Above, a group of Ute tribal members from Ignacio ride horses in native attire and headdresses around 1925. They are pictured in front of the Newman Building at Eighth Street and Main Avenue. Below, a group from the Zuni Pueblo walks along the 1000 block of Main Avenue carrying a drum along with other native cultural items in the 1950 Spanish Trails Fiesta parade. Note the four women in native dress conveying pottery water jars on their heads.

Attracting large crowds was not difficult for parade organizers. Before the advent of Christmas parades, almost every parade was held in summer or early fall. Citizens throughout the region attended in significant numbers, and many area communities entered their own bands, exhibits, floats, and marchers. Here, a local high school band entertains the crowd in the 800 block of Main Avenue during a regional band competition in 1938.

Service clubs continue to this day to be major participants and organizers of most parades. Using the parade venue as a means of publicizing the important community work they do, they also use the opportunity for recruitment of new members. At times, the clubs merely entertained onlookers with beautifully constructed floats with attractive young women riders, as evidenced in this photograph of a Rotary International float taken in 1930.

No civic group through the years has put more work and effort into its parade floats than the Benevolent and Protective Order of Elks Lodge No. 507. In 1940, the group created this rolling log saloon for the entertainment of Spanish Trials Fiesta parade attendees. The float contained a bar with gaming tables and carried about 22 men and a few women along the parade route downtown. The members wore Western clothing and acted the part of old west cowboys enjoying themselves in a gambling and drinking establishment. In the years just before the advent of World War II, the liquor laws in the county were fairly liberal. The bar on this large conveyance was actually real, and not only were the riders served, but parade watchers could purchase drinks as well. It was likely a good fundraiser for the organization.

The stated objectives of Lions International are to "create and foster a spirit of understanding among the peoples of the world." Here, in the 1920s, the local Lions Club demonstrates how its membership "strives to promote the principles of good government and good citizenship and take an active interest in the civic, cultural, social, and moral welfare of the community." The club enjoys an exceptional reputation as a parade contributor.

Dedicated activity groups and clubs found the parade an excellent way to display their efforts and accomplishments. The Whirl-A-Way Square Dance Club actually performed a square dance for enthusiastic crowds for many years in the Spanish Trials Fiesta parade. A live country band and square dance caller also rode on the float to round out the "show," keeping with the Western theme of the event. This photograph is from 1955.

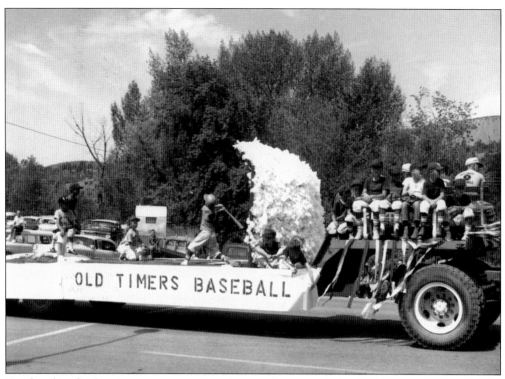

For decades, the favorite summer activity of county boys was playing "Old Timers" baseball. The free program was organized without the inclusion of parents. Starting in the 1950s, for over 25 years, the annual culminating activity for the players was participating in the Spanish Trials Fiesta parade. It was a fitting way to thank the many businesses who contributed sponsorship funds for the program. This photograph was taken in 1955.

County parks and recreation director Dolph Kuss instituted an additional children's parade for the Spanish Trails Fiesta starting in the mid-1950s. Although only held for a few years, in some respects it was just as popular with spectators as the regular parade. Kids often came up with captivating and humorous costumes and themes. Here, a Native American group of youngsters appears in traditional native attire in 1959.

In earlier days, summer parades never lacked talented marching bands. Most regional high schools brought their musicians together every August for parades. Today, schools rarely participate due to out-of-school-year insurance costs. Adults also had opportunities to perform as musicians. Service clubs and veteran organizations sponsored bands as well as drum and bugle corps. Here, a 1930s band in civilian clothes is seen at Eighth Street and Main Avenue.

The American Legion Drum and Bugle Corps is seen here at Eleventh Street and Main Avenue in a photograph taken in the early 1930s. After World War II, the corps became quite popular with returning servicemen, and the group's name was changed to Goldenaires in 1955. They were eight-time state champions in the 1950s and 1960s and also competed successfully at the national level before disbanding in 1965.

Though the dominant venue for county parades, Durango was not the only parade setting. Here, Ute tribal women carry an American flag behind a returning World War I veteran on horseback. Taken near the corner of Ignacio's Goddard Avenue and Ute Street in 1918, the photograph shows the recently burned Aspaas General Store (left) and the Ignacio Garage building (right) that still exists today.

La Plata County is located geographically such that it is not susceptible to hurricanes, tornados, or earthquakes. Through the years, the three most common calamities have been fires, floods, and train wrecks. The fire of 1889 was the first disaster to beset the new region. It burned six city blocks, caused a half million dollars in damage, and left around 100 families homeless. This is the aftermath looking east.

Some residents thought the fire of 1889 was beneficial in that the buildings burned were all wood frame constructed, and the rebuilt structures were brick and stone, which was more resistant to catastrophic fires. Nevertheless, the town replaced the volunteer fire corps, shown here around 1883, with a professional paid department. Some of these men transitioned to paid positions. The 1889 fire loss was the equivalent of $17 million in 2024.

The Swift & Company Creamery was formerly a bottling, cold storage, and ice plant built in the 1880s. Located directly across Sixth Street from the train depot in Durango, it is shown burning in this photograph from 1938. Apparently, the fire department recruited bystanders to aid in dousing the flames. A similar accompanying photograph shows the fire hose being manned by citizens. Note the people on the building's roof.

With the advent of a paid professional fire department, the equipment also improved. The department replaced the destroyed Silsby horse-drawn fire wagon lost when the firehouse burned in the 1889 fire. The above photograph was taken in 1905 inside the new fire station at 134 East Tenth Street. The horses, Tige and Mac await the next alarm with the fire crew. By the 1920s, the department had transitioned to mechanized equipment. Below, the station remains in the same location on Tenth Street. The fire chief is also unchanged. Henry Dietrich, sitting second from left in the early photograph, is now standing in front of the white Chief's car about 25 years later. The man on the ladder at the fire tower is Cyril Conway, nephew of John Conway, who sits immediately to the right of the chief in the above picture.

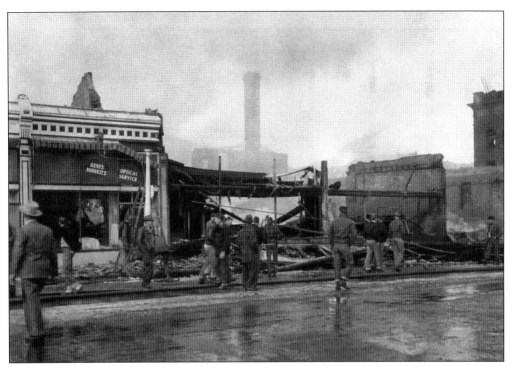

Called at the time the greatest single economic disaster in Durango's history, the February 16, 1948, fire along the north half of the 700 block of Main destroyed the town's two largest businesses, the Durango Mercantile and Graden's Mercantile. At $1 million in losses, it also heavily damaged three other businesses. The fire burned from 7:00 p.m. until 10:00 a.m. the next day. The exact cause was never determined. Inflationary adjustments indicate that the 1889 fire was still costlier. Graden's salvaged merchandise before the fire reached the store and was able to reopen within 10 days in a building just down the block. It was eventually rebuilt at the corner of Main Avenue and Eighth Street, the company's location for the next 50 years. Below, spectators view the fire aftermath from the east side of Main Avenue.

The 1974 downtown fire took over 12 hours to extinguish and ultimately destroyed six historic buildings along the west 800 block of Main Avenue. Two 24 year olds, a policeman and a fireman, were killed when a wall at the rear of the structure collapsed. The arsonist was identified, tried, convicted, and sentenced. This part of the block was completely reconstructed by 1976. The location is now known as the Main Mall.

This photograph, taken soon after the October flood in 1911, is looking north with the Main Avenue bridge, seen just beyond the streetcar. The photographer was standing near the intersection of Main Avenue and Fifteenth Street. The house pictured is about where the Veterans of Foreign Wars hall is now located. The water was six feet deep running down Fifteenth Street during the height of the flood.

Nothing compares to the flood of October 1911 in terms of widespread damage and destruction in the county. The highest volume of water ever measured on the Animas occurred. At 25,000 cubic feet per second on October 5, it was over 56 times the average flow for that date. Every river in the region raged as over 100 bridges were lost and at least two people were killed. An untold amount of crops, livestock, and structures suffered destruction or damage. The image above shows the Denver & Rio Grande Railroad bridge north of Fifteenth Street in Durango almost being overwhelmed by the raging torrent. Loaded railroad freight cars probably kept this bridge from being washed away. Below, a nearby house along the Animas River was washed off its foundation, carried downstream, and destroyed in the process.

The October 1911 flood occurred after 36 hours of steady rain. Flooding in parts of the Animas River Valley reached a depth of three to six feet. Many residents were forced to move to high ground or face the prospect of being drowned. The bridge pictured above, being nearly overwhelmed by floodwater, is the wagon bridge leading west out of Durango toward Hesperus. The bridge barely survived the flood, suffering major damage. The Rio Grande Southern Railroad bridge, just downstream in the image below, also survived but with major damage as well. An estimated 300 miles of railroad tracks were also torn apart within the flooded region. Every river in the county and adjacent counties within Colorado and New Mexico saw record-setting flood levels.

Over a 36-hour period from October 4 to 6, three-and-a-half inches of rain fell in La Plata County and four inches in Silverton. In one area north of Silverton at the storm's center, an extraordinary eight inches fell. The deluge was spawned by a Pacific tropical storm that moved onshore and remained over southwestern Colorado for two and a half days. This is high water engulfing the Smelter powerhouse building.

Twenty-two miles of track were destroyed from the Denver & Rio Grande's line between Durango and Silverton. Otto Mears, pathfinder of the San Juans, sustained over $25,000 ($800,000 today) in damages to his two railroads north of Silverton. After repairing them, the 71 year old contracted to repair the D&RG line from Silverton southward to Durango. The job was finished in 63 days. He was called a hero for his efforts.

Flooding in La Plata County has not been limited to the devastating 1911 flood. In June 1927, the Animas River peaked at 20,000 cubic feet per second (CFS) causing heavy damage. In September 1970, a peak flow of 14,000 CFS was reached. The fourth-biggest flood is the one pictured here from June 1949 in the Animas Valley with a peak flow of 12,700 CFS.

Just after Christmas in 1921, two engines leading a train toward Durango were slammed by a mixture of snow, mud, and boulders south of Tacoma. Both rolled downhill into the Animas. Of the two Connor brothers acting as engineer and fireman on the first engine, only the older one survived. The second engine crew and the 20 travelers who remained in the passenger car perched perilously above also survived.

In 1919, engineer Ralph Peake was guiding his Rio Grande Southern locomotive home to Durango. Four miles west of town, he stopped to inspect two bridges over Lightner Creek after heavy rains had turned the creek into a torrent. Believing both to be safe, he proceeded across the first bridge without problem, but upon crossing the second bridge, it gave away. Peake, unable to free himself from the cab, drowned.

Not all train mishaps were due to derailment. Rockslides disrupting the area railroads in the early part of the 20th century were common. Here, a large boulder dislodged from Smelter Mountain and rolled down into this boxcar sitting on the smelter siding. It is not certain if this car was a total loss, but the undercarriage, or truck, was probably salvaged. While impressive, this incident in 1910 did not cause injury.

Although, not technically a derailment, this washout of the Denver & Rio Grande Western tracks proved a challenge for the railroad workforce. A torrent of water from a severe rainstorm tore out the small trestle at this spot southeast of Durango as the train was moving toward Ignacio in 1934. The railroad-owned crane was used to repair the washout and shore up the tracks, allowing the cars to be moved from the precarious position.

In September 1958, a double-header train proceeding east at only 15 miles per hour through the Grandview area (near where Mercy Medical Center is today) suddenly rolled to its side when it came upon a soft spot in the roadbed. Paul Mayer, the fireman aboard the lead engine, perished in the crash, but the rest of the crew survived. This was the last fatal wreck of the Denver & Rio Grande Western narrow-gauge railroad.

Five

FORT LEWIS

The military post of Fort Lewis was established near Pagosa Springs in 1878, with some troops stationed at Animas City by 1879. It was moved to a site on the La Plata River near Hesperus in the winter of 1880–1881. This location was considered more suitable for peacekeeping between the Ute tribes and the white settlers of the county. An on-base photographer took this photograph of Bill Beecher in 1885.

Soldiers at Fort Lewis saw no real military action in the 10 years the camp existed in the county. Whether their presence was enough to prevent conflict or whether they were simply not needed is still debated. Many soldiers had their photographs taken by W.J. Carpenter at the post's studio. Not limited to wearing only their duty uniforms, a young Bill Beecher wore Western "mountain man" attire for this photograph.

Troops stationed at Fort Lewis had to find ways to prevent boredom at the isolated camp. They formed baseball teams and held theatrical productions. Here, men from the 22nd Infantry pose for a group photograph of their string band around 1885. A complete orchestra was also formed. The soldiers often played for dances and events in the surrounding towns and were central to the area's social scene.

Likely taken around the turn of the 20th century, these two photographs depict Native American boys from Fort Lewis during the boarding school era between 1891 and 1910. The students were required to wear uniform suit coats, pants, and straw boater-type hats. The image above was taken in front of the dorms with a bell tower behind, ostensibly used to call students to class, meals, or assembly. The school reached a peak enrolment of 345 in 1900 and then steadily declined. By 1910, the Department of the Interior concluded that the Indian boarding school system was "an anachronism left over from another time" and transferred ownership to the State of Colorado. The image below shows students boarding the Durango trolley on their way to a fair at the fairgrounds.

Pictured on campus, these groups of Fort Lewis boarding school students are taking breaks from classes and/or vocational activities. The school originally offered six grades. Half of the day was for education in the three R's and the other for vocational training. Boarding school students were predominately Ute and Navajo, but Apache, Pueblo, and Pima tribal members also attended. Never particularly popular with native parents, the school struggled to maintain attendance. Bureau of Indian Affairs (BIA) schools in Ignacio and Shiprock, only 50 miles distant, finally spelled the death knell for the Departmentof the Interior's Fort Lewis Indian Boarding School in 1910. The legacy of these boarding schools is not a good one. The attempts to assimilate the children into all aspects of "mainstream society" at the expense of their traditional culture have been widely condemned.

Music was a favorite pastime at the school. This is the faculty orchestra around 1898. Photographed in N.B. Herr's room, this group included Henry Ketosh (second from left). He was the school engineer and head of the blacksmith shop. His wife, a Crow tribal member, was a teacher at the school. N.B. Herr was listed as "Disciplinarian" at the school, though what other roles he performed are unknown.

Accompanying documentation to this photograph indicates that these are Fort Lewis Indian Boarding School students at Wildcat Canyon after a large flood. It also specified that they were accompanied by a Mr. Herr from the school. The Rio Grande Southern Railroad trestle is shown as the tracks wound their way up the canyon on their way to Hesperus and eventually to Ridgeway. The photograph dates to around 1900.

The Fort Lewis Indian Boarding School provided more than simple academic and vocational instruction to the students. There were other activities to round out the education as well as to help prevent boredom at the isolated campus. The above photograph from 1900 is the school baseball team that competed against surrounding communities. Note the straw hat on the ground. This was part of the school uniform seen in other images taken around the same time. Female students are pictured in the photograph below attending guitar lessons as given by matron Ada Ryker Miller. The girls are all unidentified, but the one at the top left is presumed to be Miller's daughter. Miller was also the school nurse.

These two photographs, while similar in nature, display a fundamental change at the Fort Lewis Indian Boarding School. The above image was taken prior to 1911 when nearly every student was Native American. The image below was taken after Colorado assumed management of the school in 1911. By the 1912 academic year, it functioned as an agricultural high school offering an education for any area resident. A number of non-natives had since joined the marching band when this image was made. As a boarding high school, many of the students, both Native American and non-native, still lived on campus since commuting daily from isolated rural areas was impractical. Fort Lewis Indian Boarding School bands were highly regarded in the region and would perform for parades and many other community events.

By 1912, the Indian boarding school had transitioned to a state-run agricultural high school. Native, Hispanic, and Anglo students attended. Most still lived on campus, but the cultural assimilation goals of the Indian boarding school system were abandoned. These two young men are presumed to be some of the first students to enroll after the transition. They no longer wear the Euro-American type uniforms previously required.

Relocated from Pagosa Springs, Fort Lewis was established on the banks of the La Plata River. Looking toward the northwest, this is the school around 1911, with the La Plata Mountains in the background. The site was selected by the Army after first considering another one on the Mancos River. The post was moved to La Plata County to heighten the protection of mining interests in the San Juan Mountains.

Both students and faculty needed diversions throughout the school's existence near Hesperus. The trip to and from the city of Durango could be an all-day affair, so campus activities grew. In the picture above, the faculty whist club is gathered for a photograph on campus. Whist was a very popular trick-taking card game of the 18th and 19th centuries. More physically demanding activities were also encouraged. A bicycle club was organized in the late 1800s. Tennis became another campus pastime when a makeshift court was constructed. Below, faculty from the tennis club are pictured in 1900. The only identified person in the image is Martha Clarke, on the left. She taught first grade, art, and sewing.

This 1920 basketball team at practice seems a bit unenthusiastic. They are in the new field house constructed that year. A spectator balcony surrounding the entire court was considered state of the art. Teams competed with other area high schools, including some from New Mexico and Utah. Built completely with wood, the gymnasium was demolished in the 1980s, though much of the wood was salvaged for nearby home construction.

When the Colorado State Board of Agriculture began operating the school in 1912, it was designated as a Normal School. By definition, a Normal School prepared teachers, but vocational education was also key to the curriculum. Classes in agriculture, carpentry, and machine shop were offered for boys. Girls, first enrolled in 1914, took teachers' training and were offered courses in the typical domestic art subjects of the day.

This photograph, taken in 1920 in the new gymnasium, shows Fort Lewis high school coeds celebrating May Day. The isolated campus required staff and students to be resourceful in their entertainment. The Maypole dance is a ceremonial folk dance performed around a tall pole decorated with foliage, flowers, and streamers. It is a spring ritual that originated from ancient dances around a living tree.

The school consistently kept ties to Durango both socially and economically. The Durango business community lobbied for the school to be taken over by the state when the Department of the Interior decided to close the Indian boarding school in 1911. By 1933, high school classes were discontinued, and Fort Lewis soon became a junior college. This is the school's float in a Durango parade during the early 1930s.

The campus of Fort Lewis Junior College was moved to Durango in 1956. Growth immediately ensued, both in terms of student population and academic offerings. By 1963, baccalaureate degrees were being granted as the school transitioned to a four-year college. Here is a bird's-eye view of the campus six years after the move to the mesa just east of downtown Durango. The Durango Municipal Airport was formerly located at this site. In the 2023–2024 school year, 3,425 students were enrolled. When the State of Colorado accepted the property in a grant from the federal government in 1911, it agreed to maintain it as an institution of learning and admit Native American students free of tuition. This promise from the state still exists today. An average of 1,400 Native Americans, representing 185 tribal nations, enroll each semester at Fort Lewis College.

Six

THE FAIRGROUNDS

Located along north Main Avenue, this site has served as a fairground for La Plata County since 1890. Initially owned by the Durango Railway and Realty Company, a trolley operator and land speculator, the property was sold to the county in 1917 for $10,000. The 40-acre, county-owned tract was situated between the boundaries of Animas City and Durango. This photograph is from September 1948, the year Durango annexed Animas City.

Taken from an airplane during the Spanish Trials Fiesta Rodeo and Horse Races in 1946, this photograph gives a good view of how the complex looked prior to being renovated in 2000. The grandstands are full, holding over 7,000 people. At the bottom right, the starting gate for a horse race is positioned across the track.

This original wooden grandstand was built in 1896 and destroyed by fire in 1930. Large open-air bleachers were erected soon thereafter but were relatively short-lived, as the Works Progress Administration (WPA) started erecting the large 600-foot stone grandstands in 1936, completing the project in 1938. The WPA engaged over 200 previously unemployed workers in La Plata County in 1936, the majority hired for the fairgrounds project.

The front side of the original grandstands can be seen in this Pen-Dike Studio photograph from the 1910s. These 11 players are presumed to be teammates, though the monogrammed "M" is of unknown origin. It likely signified Mancos or Montrose. The "D" for Durango is evident. Baseball was played at the fairgrounds as early as the 1890s.

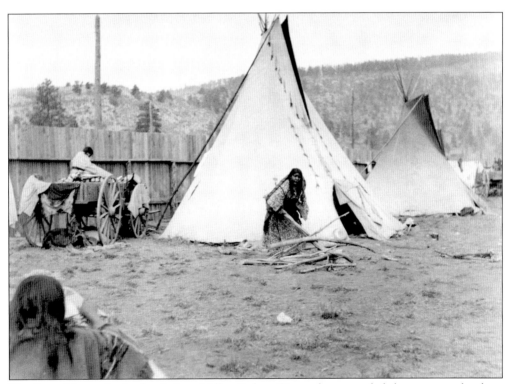

The first white settler in the Animas Valley, Robert Dwyer, homesteaded the property that later became the fairgrounds. Located between Durango and Animas City, the ranch was sold by Dwyer to the Durango Railway and Realty Company in 1891. Part of the property was developed for horse racing and fairs, becoming known as the fairgrounds. Here, a group of Ute tribal members are encamped during the Colorado–New Mexico Fair of 1900.

As horse racing was a favorite pastime of the populace, a reliable centralized racetrack was imperative for La Plata County citizens. The fairgrounds were originally established as a place to test a horse's speed. Wagering was important, but the bragging rights of owning the fastest horse were also of major importance to successful ranchers. It was not uncommon for horsemen within the county to issue public challenges to test their horses against one another for prestige

and money. The Colorado–New Mexico Fair, held annually at the fairgrounds starting in the late 1890s, was a favorite venue for regional horse racing. Horses from throughout Colorado and New Mexico would descend upon the community for four days of running. Two famed regional horses that garnered widespread reputations and wagering support for a number of years were Silver Dick and Big Tom.

The fairgrounds were the primary location for horse racing in the county from its beginning in the early 1890s. Here, in 1908, a well-attended race is witnessed by spectators during a time when horses still provided the main means of transportation for the region. Attendees are wearing their Sunday best as a day at the races was considered a societal event.

If horse racing was the first true use of the fairgrounds, rodeo was not far behind. Initially, the facility did not have what today would be considered a rodeo arena. Organizers utilized the race track for rodeo events in the early days. The rodeo also did not include all of the events most people know today. The early rodeos consisted predominantly of "broncho busting," sometimes steer riding, and calf roping.

Races at the early fairs were not limited to what today might be considered normal racing. Some races were limited to only Native American riders. Others were relay races with even a footrace included as a leg of the relay. Women-only races and a number of humorous novelty races were sometimes included. At the fair in 1910, men were required to race 200 yards on their horses, dismount, slip into a lady's nightgown, and return to the starting point. The winner was awarded $10 ($181 in 2024). In the image above, tribal members race in 1919 with the original grandstand visible. Note the Stein Mercantile Company advertising "Ladies FINE Shoes" on the side gable. In the image below, jockeys urge their mounts around the first turn at the 1948 Spanish Trails Fiesta race meet.

The fairs at the county fairgrounds offered much more than just horse races, rodeos, and agricultural exhibits. The Edwards family of Durango provided this boxing exhibition around 1910. These twins were coached by their father. Their older brother is shown watching. James "Dixie" Edwards, a porter on the railroad, made extra money with his family by entertaining the community with music, dancing, and athletic exhibitions like this one.

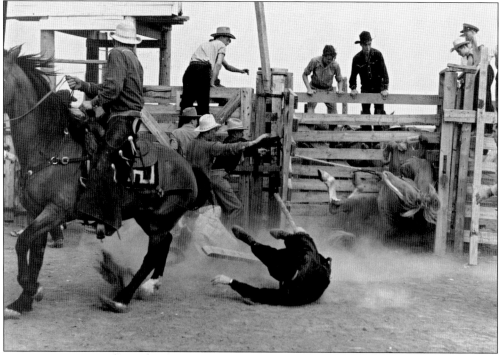

Until 1935, the Colorado–New Mexico Fair was the principal yearly event at the fairgrounds. In 1935, a group of businessmen and ranchers adopted the name Spanish Trials Fiesta and started an annual event that included parades, horse races, street dances, and most notably a rodeo. By the time the WPA finished the new grandstands and rodeo arena in 1938, the fiesta had become exceptionally popular. This image was taken in 1941.

118

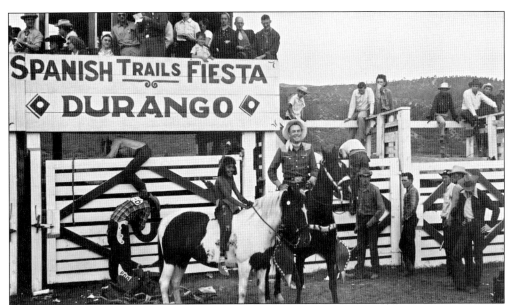

Organizers of the fiesta wanted to accentuate the county's location on the Old Spanish Trail, the main trading route from Santa Fe to Los Angeles from 1830 to the mid-1850s. With the designation of the federal highway tourism route through the Four Corners called the Navajo Trail in the 1960s, the name was changed to Navajo Trails Fiesta in 1966 to heighten awareness for tourists and travelers. In the 1980s, the event name became Fiesta Days. The 1956 rodeo picture featured Red Ryder and Little Beaver from the popular newspaper comic strip of the day. Red Ryder was portrayed by the comic strip artist Fred Harmon, and Little Beaver was played by a young Jicarilla Apache youth. Locals were encouraged to dress in traditional Western wear throughout the three-day event, and most did so, as seen by these spectators at the 1939 rodeo.

Captioned "First Plane to Land in Durango," this photograph was taken at the Colorado–New Mexico Fair in 1913, about 10 years after the Wright brothers' first flight. The demonstration was a major draw, even though many people doubted the safety of allowing a plane to fly over the city. The plane, a Curtiss Model-D biplane, was not flown to Durango. It arrived on the train from Pueblo and assembled on-site.

County athletes used the fairgrounds for about 25 years as their track and field competition venue. Entrants from throughout the county gathered there for competition in the usual events, but also some that are not well known today. The standing broad jump, hammer throw, baseball throw, and a "potato race" were included at early meets. By 1926, schools had their own track and field venues. This pole vault event is from 1917.

This baseball game pictured at the fairgrounds is from around 1911. Games were played there as early as the 1890s. One of the first baseball games played in the county was the 8-3 Durango win over the Silverton nine during the August 1881 celebration of the arrival of the Denver & Rio Grande Railroad. That game was played along what today is Tenth Street, east of Main Avenue. Over 1,500 spectators attended. Football was played in the county at least as early as 1893. Town teams played Fort Lewis school squads as well as smelter worker teams and neighboring towns such as Montrose. Various sites were utilized for games, but the predominant site after the turn of the 20th century was the fairgrounds, with games played there until 1977. This game was played in 1920.

During the 1950s, stock car racing was held about two miles west of the fairgrounds, up Junction Creek Road. In 1968, it moved to a track at Grandview, east of town. Throughout the years, however, the fairgrounds also accommodated car racing. Motorcycle races were held there as early as 1913. Demolition derbies and dare-devil thrill shows like this one were also popular events, usually held during the annual fiesta.

The La Plata County Fair can be traced back at least to 1888. Many regional fairs and exhibitions have been held at the fairgrounds since, but the modern version of the county fair started in 1948 when the La Plata County Fair Incorporated was formed. The 2023 edition had the theme "75 years of Kids, Critters and Cowboys." This livestock judging event is from 1959.

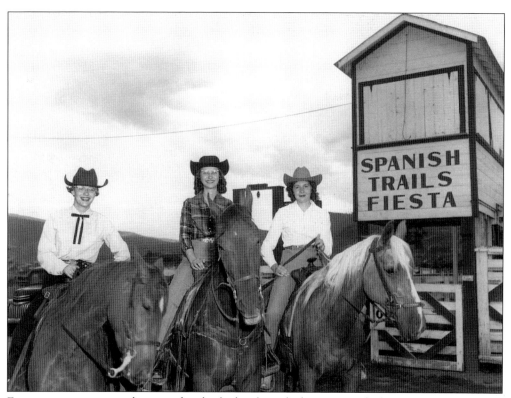

Equestrian activities predominated at the facility from the beginning. The large oval track provided a convenient, safe venue for horseback riding and training. Over 100 horse stalls were available for rent. The Spanish Trails Fiesta, later to become the Navajo Trails Fiesta, highlighted Western horsemanship. Here, 1958 Fiesta Queen Sylvia Gilchrist (left) is accompanied by her attendants Linda Bauer (center) and LaDonna Snow (right).

The fairgrounds have been home to events, shows, fairs, exhibitions, and recreation for more than 125 years. For 42 summers it hosted the local youth baseball "Old Timers" program. The county recreation program made good use of the venue for numerous activities, such as adult men's and women's softball, ice skating, and, as shown here in 1955, youth archery instruction.

This image from 1974 shows the 600-foot grandstands, racetrack, rodeo arena, football, and baseball fields. The two-block-long row of horse stalls created a stone wall along Main Avenue. In addition to regional and county fairs, the fairgrounds have hosted horse racing, rodeos, livestock shows, 4-H activities, equestrian events, and the annual Spanish Trails Fiesta (later known as the Navajo Trails Fiesta). It was also the site for circuses, auto races, demolition derbies, Fourth of July fireworks, and many recreational activities. High school football, baseball, and youth league baseball games were played on the fields. When built by the New Deal's Works Progress Administration in 1936–1937, over 200 local laborers who had lost jobs during the Great Depression were given employment. Starting in 1999, the grandstands, racetrack, interior rodeo arena, ball fields, and horse stalls were removed within two years.

Filled to capacity, this 1974 view of the grandstands and racetrack between horse races is looking north with Animas Mountain in the background. Introduced in the 1970s, pari-mutuel wagering at the Navajo Trails Fiesta race meet substantially increased attendance and profits for the fiesta association. Unfortunately, the deterioration of the facility over 50 years of continued use spelled the death knell for the large grandstand and many of the events it served, like these horse races. By the early 1980s, the facility was judged unsafe, resulting in the Navajo Trails Fiesta being nearly abandoned. A group of committed county citizens refused to let the tradition fall by the wayside. Renamed Durango Fiesta Days in 1986, albeit without horse racing, the Western-themed celebration is still popular today, though not nearly so much as in its heydays of the 1960s and 1970s.

Today, the fairgrounds exist as only a shadow of its celebrated past. In 1999, the Works Progress Administration–constructed 7,000-seat grandstand was removed, as were the original large rodeo arena, football field, and the adobe horse stalls along Main Avenue. Most of the site was repurposed with two baseball fields and a large City of Durango recreation center, along with a smaller rodeo arena and a new exhibit hall. The county continues to maintain two pavilions used for various events, including the annual La Plata County Fair. Above, the two-block-long adobe row of horse stalls are being demolished in September 1999. Below, the 1937 New Deal–constructed 600-foot-long grandstands are being removed in early 2000.

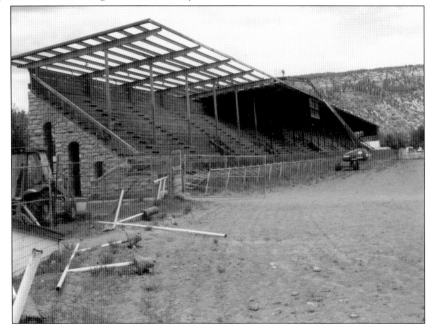

ABOUT THE ORGANIZATION

The Animas Museum is owned and operated by the La Plata County Historical Society (LPCHS), with the mission to keep La Plata County's history and culture alive for present and future generations. The face of that mission is the Animas Museum, but the society does much more. The permanent collection of the museum is the community's memory; the objects, photographs, and documents tell the stories of those who came before us. That past can then inform the future. Exhibits at the museum explore how Native Americans, education, mining, ranching, fires, the railroad, law enforcement, and tourism have shaped La Plata County.

The La Plata County Historical Society was organized in 1972 and incorporated in 1974. In 1978, Durango School District 9-R deeded the former Animas City School (built in 1904–1905) to the LPCHS for use as a museum. The Animas Museum started taking collections in 1978 and opened officially in 1983. The society also holds facade easements on several historic buildings in downtown Durango. Preserving the architectural heritage of the area is important to cultural and heritage tourism.

The La Plata County Historical Society has been honored by state and national history organizations, receiving the Josephine Miles History Award for the restoration of the Peterson House on the museum grounds and its exhibit exploring the Great Depression in La Plata County, which opened in 2019. Keeping history alive depends on the value we place on it.

Discover Thousands of Local History Books Featuring Millions of Vintage Images

Arcadia Publishing, the leading local history publisher in the United States, is committed to making history accessible and meaningful through publishing books that celebrate and preserve the heritage of America's people and places.

Find more books like this at
www.arcadiapublishing.com

Search for your hometown history, your old stomping grounds, and even your favorite sports team.

Consistent with our mission to preserve history on a local level, this book was printed in South Carolina on American-made paper and manufactured entirely in the United States. Products carrying the accredited Forest Stewardship Council (FSC) label are printed on 100 percent FSC-certified paper.

MADE IN THE USA